IMAGES
of America
WALNUT CREEK

ON THE COVER: The day of the first Grape Festival in Walnut Creek was October 5, 1911. Main Street was decorated from Mount Diablo Boulevard to Civic Drive. The entrance to town sported two grape arbors across the street anchored at the four corners by towering stacks of baled hay. Horses and automobiles were decorated, grapevines hung from porches and storefronts, and clowns added to the festivities. (Courtesy Contra Costa County Historical Society.)

IMAGES of America
WALNUT CREEK

Catherine A. Accardi

ARCADIA
PUBLISHING

Copyright © 2009 by Catherine A. Accardi
ISBN 978-0-7385-5991-9

Published by Arcadia Publishing
Charleston SC, Chicago IL, Portsmouth NH, San Francisco CA

Printed in the United States of America

Library of Congress Catalog Card Number: 2008933028

For all general information contact Arcadia Publishing at:
Telephone 843-853-2070
Fax 843-853-0044
E-mail sales@arcadiapublishing.com
For customer service and orders:
Toll-Free 1-888-313-2665

Visit us on the Internet at www.arcadiapublishing.com

Contents

Acknowledgments		6
Introduction		7
1.	In the Beginning	9
2.	A City in the Valley	27
3.	Neighborhoods, Residences, and Recreation	49
4.	Tunnels, Trains, and More	77
5.	People, Places, and Events	101

ACKNOWLEDGMENTS

This book would not have been possible without the assistance of the members and staff of the Contra Costa Historical Society and History Center. Unless otherwise noted, all images are provided by the Contra Costa County Historical Society.

INTRODUCTION

Walnut Creek is a dynamic community located in central Contra Costa County. The community is well served by major freeways and mass transit and has a long history of careful strategic planning to capture economic opportunities. Today Walnut Creek serves as the regional "downtown" for much of Contra Costa and eastern Alameda Counties, with dense urban development in the city's downtown core. This transformation, over a period of 200 years, 1792 to 1992, is a remarkable and important story for our society's understanding of everyday life. This book will focus on the people and the places that created Walnut Creek.

The journey of the city called Walnut Creek includes its ranches, businesses, prominent citizens, schools, churches, tourist attractions, historic sites, and stunning natural areas. The city is named for the waterway meandering through its neighborhoods, Arroyo de las Nueces. This book, and its images, depicts a place that grew from farmlands and fields to become one of the San Francisco Bay Area's most cosmopolitan and desirable residential cities.

Tradition has it, as it was handed down among the early Spanish families, that Padre Juan Crespi and Pedro Fages first trod in the area of Walnut Creek on their way to their discovery of San Francisco Bay. After the padres, the Spanish adventurers came and discovered the rich land and abundant water. According to historians, the original diaries of the first Spanish explorers clearly describe life in the Walnut Creek area. The first group of explorers passed through the area of Walnut Creek on April 1, 1772, under the command of Pedro Fages. The second group to explore the areas was under the command of Juan Battista de Anza in April 1776. By 1822, Mexico had acquired possession of California and wished to settle its new territory quickly. Land grants were the vehicle by which this was accomplished, and by 1828, occupation of ranchos in the Walnut Creek area began.

And so it went until November 1841, when the first immigrant wagon train came into the area. The wagon train was led by wagon master John McDowell and consisted of farmers from Kansas, Missouri, Illinois, Iowa, the Dakotas, and Colorado. Fourteen men, some with families, arrived to build new lives. Some were able to purchase land from the rancho heirs and stayed to build cabins and develop the land. Many did not come to dig for gold in California's rich gold mines. They were farmers who knew gold would come from planting wheat, oats, barley, fruit trees, and vineyards in the lush soil of the area. Historical records indicate some of these farmers purchased land from the descendants of the Spanish dons for 25¢ an acre.

As time went on, raising cattle was replaced by grain crops. Walnut Creek is at the foothills of Mount Diablo, so it was, and is, an area of many hills and springs. By 1855, fruit crops were established, including pears, apricots, prunes, and peaches. Later, in the years between 1875 and 1895, these crops brought fortunes to farmers. Later still, large orchards of walnut trees were planted.

William Rogers arrived in 1878, and by 1880, he decided the village needed a new hostelry, so that year, he built the Rogers Hotel on the northeast corner of Main and Duncan Streets. The Rogers Hotel was a two-story structure.

By 1880, the village population totaled about 300 people. Milk cows were tethered on the vacant lots. Residents made butter and kept chickens. Reports are that dry dirt on Main Street was frequently sprayed with water to keep the dust down. At this time, stagecoaches stopped at the Rogers Hotel on Main Street from all four directions—east, west, north, and south. Passengers stopped for refreshments at the hotel or at Burgee's Saloon across the street. The village stable housed the horses at the Hodges barns while the harness room, wagon shed, and corrals filled the entire block of what is today Main Street and Broadway, between Duncan Street and Mount Diablo Boulevard.

Before the Walnut Festival began in 1936, and before the 1911 Grape Festival (depicted in the cover photograph), the approximately 450 Walnut Creek residents held a fair called the Moonlight Circus in China Alley, now renamed Cypress Street. The year was 1894. The speaker's platform was decorated with Chinese lanterns, and coal oil lanterns lit each booth.

The event began at 8:00 p.m.; lemonade was sold along with pineapple syrup, ice cream, and homemade cakes, and popcorn was plentiful.

Time marched on and progress made its way into the small town. Telephone service for Walnut Creek is reported to have begun in 1881 when the line ran from Martinez to Walnut Creek, but few residents felt the need for a phone in those days. By 1904, only six people had subscribed to phone service. The first homes and businesses received electrical service in 1910.

The Corners was officially renamed Walnut Creek with the establishment of the U.S. Post Office in December 1862. The Corners marked the spot where four dirt roads leading north to Vallejo, south to San Jose, east to the coal mines, and west to Oakland/San Francisco met. At this time, there was still a volunteer fire department, streets were still unpaved, and horses still outnumbered automobiles. Electric lights slowly appeared after 1910. Historians consider the years 1910 to 1914 as the period of major changes to the area we know now as Walnut Creek. As the years passed by, the hamlet matured into a village with its own identity. Electric trains began serving the area. Why, one could make the trip to San Francisco in only one hour and 15 minutes! The year 1911 brought the first library, established by the Women's Improvement Club, later called the Women's Club of Walnut Creek. And then the town incorporated on October 21, 1914. The hamlet had become a city.

George C. Compton published the first edition of the *Contra Costa Courier* in May 1911. Later this publication merged with the *Danville Journal* into the *Contra Costa Courier-Journal* until July 1947. During this time, ownership changed several times, including to Dr. Harry (dentist) and Maude Silver in 1921. Dean Lesher bought the *Courier-Journal* in July 1947, then with a circulation of 2,000. He renamed it the *Contra Costa Times*.

The years 1920 and 1921 brought paving to Main Street and the first service station. In 1925, city limits expanded from one square mile to 42 square miles. Population topped 1,000 in 1930, 1,587 in 1940. Completion of the Highway 24/Interstate 680 interchange in 1960 further increased Walnut Creek's desirability, and population zoomed up to 9,903. Then came the Bay Area Rapid Transit System (BART) service on May 21, 1973. Population zoomed again up to 53,643 in 1980 and 60,569 in 1987. Citizens of the Creek were pleased when the Regional Center for the Arts (renamed the Lesher Center for the Arts in 2007) opened on October 4, 1990. Walnut Creek is a city in the Diablo Valley its citizens can be proud of.

One

IN THE BEGINNING

Chapter one, "In the Beginning," will describe and depict, in historic images, the period from 1792 to 1913. It should be no surprise that, in the early days, the location of man's settlements depended in large part on the availability of water. Several streams meandered through the valley where Walnut Creek grew from a hamlet to a city. The first settlers relied on stream water; later they hand dug wells, later still elevated tanks supplied water for hand-pumped wells, and later windmills moved precious water.

Excavation for the First National Bank building on Walnut Creek's Main Street unearthed Native American mounds revealing the existence, in centuries past, of an aboriginal race. In these excavations, skulls and bones were brought to light along with stone utensils, trinkets, and tokens of exchange.

The diary of Padre Juan Crespi records two Native American tribes with villages in Walnut Creek around 1772: the Saklan and the Bolgones. Artifacts were found by archeologists when bulldozers cleared land for the development of the Rossmoor area. Legend has it the Native Americans gave the name of Devil's Mountain to Mount Diablo because of the heat of the valley and the potential of the mountain's early volcanic activity. By 1769, the Spaniards arrived in the area and declared that Spain owned the land. After the 1821 Mexican revolution, the Mexican government began issuing land grants.

The arrival of the first immigrants in 1841 brought approximately 14 men and their families, settling near Arroyo de las Nueces (Creek of the Walnuts). In 1847, William Slusher and his family built the first cabin near the creek, at the site where Mount Diablo Boulevard and Broadway intersect today.

The Corners marked the spot where four dirt roads led north to Vallejo, south to San Jose, east to the coal mines, and west to Oakland/San Francisco. It is a little-known fact that the first European settlers built homes between the four creeks that converged at this site known, then and now, as the Corners. Those creeks—Arroyo las Trampas, Tice Arroyo, Arroyo de las Nueces, and Arroyo del Injerto—allowed a thriving community of early residents to build prosperous farms and businesses. The transformation from hamlet to town had begun.

Pictured is an early drawing (mid-1800s) of the area now known as Walnut Creek depicting Arroyo de las Nueces. The drawing reads in Spanish, "De diseno de un sitio baldio situado al s.o. del Monte Diablo pedido por Dona Juana Pacheco." Translated it reads, "Design of an uncultivated site located under the mount of the devil requested/ordered for Don Juana Pacheco."

The drawing above depicts three men in front of the Walnut Creek Hotel in 1850. Rumor has it that this image is of two men who were gold diggers and a younger man who was Levi Strauss having a conversation on Main Street in Walnut Creek. Supposedly young Strauss stopped in Walnut Creek for refreshments while on his way to California's gold country or possibly on his way to San Francisco, where he later established the Levi Strauss Company. (Courtesy Robert Hunter.)

This is one of the earliest street scenes of Walnut Creek and is considered one of the oldest known photographs of Walnut Creek in the mid-1870s. Records indicate this was taken on a glass negative. The image looks north at the corner of Main Street, then called Pacheco Road, and Oakland Road (later renamed Lafayette Road and later still Mount Diablo Boulevard). Townsfolk look toward the camera, stopping their life through time for just a second. From left to right are the Albert Sherburne Mercantile Store, Pierson's Emporium, Cameron's Blacksmith Shop, and Kimball's Tin Shop. The village, as it was called then, had a population of 300 people. Most residents tethered a milk cow on one of the many vacant lots in the village, while townsfolk made their own butter. In dry weather, a tank wagon sprayed water on Main Street to keep dust from flying into every house and shop.

Here is the Livery Feed Station on the right in 1873. Standing out in front are a young man in the middle of the dirt roadway of Main Street, a man and horse, and assorted people watching the photographer take the picture. It appears to be a relatively quiet day on Main Street looking north from Mount Diablo Boulevard. The livery stable was owned by F. Sanford. In the center is the Rogers Hotel. In 1860, James McDonald and Charles Whitmore established the first mercantile business in Walnut Creek. Their store was located on what is now Main Street, at the northeast corner of Lafayette Road. Afterward they sold out to H. P. Penniman and W. H. Sears. Milo J. Hough opened the first hotel in 1860 on the site where J. C. Laurence later placed his home. He had a blacksmith shop opposite the hotel. About this time, the Morris brothers operated a stage line between Oakland and Clayton via the old Fish Ranch Road, which then came through the hills approximately at the site of the current Claremont Hotel.

Pictured above around 1880 is the Oak Saloon at the southwest intersection of what is now Mount Diablo Boulevard and Main Street. The Mike Kirsch home and blacksmith shop are on the left. The old oak tree in front of the hotel stood for many years. The narrow grass-covered lane to the left is now South Main Street. A dirt path led past the Kirsch Blacksmith Shop in the left corner, then turned right and ran along the west bank of Las Trampas Creek, crossing a small bridge to connect with the road south to Alamo and Danville. A quote from the *Walnut Creek Independent* newspaper of Friday, June 9, 1882, reads: "Oak Saloon. Cor. Main St. and Oakland Road. C.W. Rogers, Prop. None but the finest brands of Wines, Liquors and cigars kept. I have also added a fine Billiard Table. The public will always be treated with the greatest courtesy."

The northwest corner of Mount Diablo Boulevard and Main Street is shown in an 1883 southwest view. From left to right are the Oak Saloon, Sherburne Brothers Store, Walnut Creek Fire Department, and Real Estate Building. This would be the new Sherburne Store, built in 1880, as the first store burned in December 1879. The first Sherburne business was one of many business ventures during the 1860s and 1870s. In 1864 and 1865, the business activities of Walnut Creek were developed by L. G. Peel, who established a store opposite where St. Mary's Catholic Church was later located. He also purchased the Hank Sanford ranch, later owned by the Botelho family. Peel sold his store to Albert Sherburne. In 1871–1872, John Slitz added another store to the business community. He dealt in groceries and hardware, was a notary public, and was appointed postmaster. When he resigned as postmaster, the position was taken by James M. Stow, who was appointed by President Hayes. Stow purchased the store.

This is the first town hall at the northwest corner of Main and Bonanza Streets around 1885. The town realized it needed a public meeting place, so the Town Hall Association was formed consisting of five community leaders. The town hall was particularly important to citizens before incorporation of the town in 1914. The Town Hall Association served the needs of the citizens when the town's population was just hovering around 450. Originally, the site of this first town hall was the location of the Homer Shuey Store, later the Geary Store. The Shuey brothers, Homer Stow Shuey and Marcus Shuey, who had been conducting a general express and produce buying business, engaged in general merchandizing in 1871. They sold their business, then on the site of the town hall, to C. W. Geary. When the Geary store burned to the ground, at a loss of $20,000, the lot was taken over by Xarissa R. Hill, and she generously deeded it to the community as the site for a town hall.

Above is an 1890 photograph of the Joel Harlan Livery Stable, formerly the Livery Feed Station. This charming image of a man and horse was taken on the east side of Main Street between Mount Diablo Boulevard and Duncan Street. Some residents had their own corrals, while many others kept their horses at the stables.

This 1896 photograph, taken at the Rogers Hotel at the corner of Main and Duncan Streets, looks south. Pictured are the Sherburne Store, Burpee Saloon, and the firehouse. Burpee's Saloon was another popular stop for stagecoach passengers who stopped in front of the Rogers Hotel. Cool beverages were an important part of any long dusty trip in the early days.

Pictured above is the Walnut Creek Meat Market in 1900. This structure was built by Arthur Williams on the east side of Main Street near Bonanza Street. Williams built the structure in 1900, and he is pictured above wearing a butcher's apron by the meat market wagon. Williams sold the market to three butchers—Foskett, Ellworthy, and Keller—and they sold it to Jesse Lawrence in 1910.

This is a view of dusty Main Street looking north in 1890. Residents tethered cows on one of the vacant lots in the village. They made butter and kept chickens. When the weather was dry, this village scene included a tank wagon, which sprayed water on Main Street to keep clouds of dust from flying into houses and shops.

Dusty Main Street looks north in 1890 farther up the dirt road with the Rogers Hotel on the right. Across Main Street was a row of small buildings that housed the firehouse, the undertaker, the barber, and a dentist.

This sketch of a 1910 map of property ownership also shows the Oakland and Antioch Railroad right-of-way. Historians agree the years 1910 to 1914 brought considerable changes, progress shall we say, to Walnut Creek. Population averaged around 450. The demand for farms in the surrounding valleys persuaded many owners to divide some of their land.

In this view looking north, a man on the right is posing for the camera next to an automobile of the day. The year was 1911. The cameraman is standing on the east side of the Rogers Hotel and Voslander Building. On the west side is the Stow Building with its two towers, drugstore, and post office.

Jump forward one year to 1912 in this photograph of Main Street looking south from the corner of Cypress Street. Note the charming ice cream store on the left. Eventually Ed and Guy Bradley, confectioners who opened the first confectionery in town, established a soda fountain at 1370–1374 Main Street in the center of the business district.

19

Here are a horse and buggy in front of the Rogers Hotel in 1900. Readers may be able to see the little dog at the left behind the buggy. Also note the horse watering trough on the right below the Rogers Hotel sign. Early California pioneer William B. Rogers decided Walnut Creek was in need of a new hostelry, so in 1880, he built the Rogers Hotel.

Stagecoaches made the Rogers Hotel their Walnut Creek stop. The stage line commenced its run to Oakland in front of this establishment. But it wasn't just stagecoaches, horses, and buggies that stopped at the Rogers Hotel. Pictured above are the Bay City Wheelman bicycle riders taking a rest c. 1903.

The Rogers Hotel bar quenched the thirst of many a citizen and traveler in its day. Horses would drink from the trough in front of the hotel while passengers quenched their thirst at the bar. In addition, the two-story structure offered a parlor, dining room, and sleeping rooms above.

Men standing about in front of the E. Ignace general merchandise store on Main Street in 1910 might have been waiting for the electric lights to be turned on. This store, built of brick by James M. Stow, was the first commercial building to have electric lights in November 1910.

This image looks at the inside of the Acree and Silver Store at the northwest corner of Main Street and Mount Diablo Boulevard. On the left is Harry T. Silver, and on the right is James L. Acree in 1912. The awning on their shop read, "Acree and Silver General Merchandise." The 1930 Contra Costa census shows a James Acree, wife Louise, and daughter living on Bonanza Street.

In the beginning, the hamlet was not just about business on Main Street. The year 1911 brought the Grape Carnival pictured above. Citizens were celebrating a successful grape harvest. At this time, grapes were the best-selling crop. Main Street was lined with bales of hay, and prizes were given for best wines, walnuts, olive oil, and grape juice.

The Grape Carnival was enjoyed not only by the citizens of Walnut Creek but encouraged other nearby communities to join in the camaraderie and festivities. The photograph above is of the Alamo float. A popular event was a baseball game between men from Walnut Creek and Concord.

Schools were an important community element for families. Pictured here is a c. 1890 Oak Grove School class. The first official school was founded in 1854. It was a one-room schoolhouse built on the northeast corner of Oak Grove Road and Ygnacio Valley Road. After many years, a two-room building, with indoor toilets, replaced the original structure.

Pictured are teacher Lena Anderson and her school class in the 1890s. The first version of the village's school was called Central Grammar School, which opened in 1861. E. B. Anderson, Lena's husband and mayor from 1928 to 1930, wrote of his experiences as a schoolteacher and principal of Central Grammar School. According to Anderson, it was a tough school, with students who attended school only six months each year and worked in the family orchards the other six months.

The Central Grammar School appears here in the early 1900s, located atop a hill at the south end of School Street (now Locust Street). Built in 1870, it had two rooms. The structure was replaced in 1912 with a four-room school. Records indicate school enrollment in 1860 was 28; by 1875, it was at 62; and by the 1890s, it was recorded at 75. Mrs. J. Hargraves, who had children of school age, decided to open a school for kindergarten through the third grade on her ranch in 1857.

Maude Jones is the teacher on the far right with her 1907 class at the Central Grammar School. For approximately 50 years, students of the Walnut Creek Grammar School went up only to the eighth grade. Higher education was taught in the area's public schools when the Mount Diablo High School opened in 1901 in Concord.

Village life was not just about the downtown; the village was nestled in the valley at the foot of Mount Diablo. Cattle were raised, crops were grown, and hay was hauled. This particular image is at the Spait Ranch. Both the man and the horse seem to be enjoying their life on the farm. Until the 1880s, farmers grew grain to sell and hay to feed their animals.

By the 1890s, almost half the farmers planted fruit orchards. More income for farmers prompted more businesses to establish in town to service the communities' needs. Successful crops of the day included grapes, walnuts, and pears. Pear orchards were an inviting sight for children to play in and about. It is easy to imagine youngsters sitting under the shade of these trees, enjoying juicy pears.

Here is Main Street, near Botelho, leaving the hustle and bustle of the village behind and meandering south, out of town, around 1900. This is a charming scene near the Stow Ranch and the Webb house. In those days, Walnut Creek was a rural place of farmland, meadows, trees, and rolling hills surrounding the hamlet.

Two

A City in the Valley

The hamlet becomes a town in chapter two, "A City in the Valley," covering the period from 1914 to 1992. This chapter will document the historical progression of a family-oriented town marching through the decades. Incorporation of the City of Walnut Creek in 1914 was highlighted by extraordinary growth. New residents flocked to Walnut Creek from around the nation. Schools, churches, and businesses thrived in the family-oriented environment. Surrounding the charming city of Walnut Creek was an abundance of natural beauty, nestled in the dynamic Diablo Valley.

As time marched on, and the city continued to mature, 1916 brought the first telephone exchange to Walnut Creek in the Bradley brothers store on the 1200 Block of Main Street.

By 1919, the women of the switchboard handled 78 customers. In 1930, Main Street was given to the state as part of the state highway system but returned to the city in 1939 after Highway 24 was built. The downtown, more quaintly known as Old Town, included the first schools, churches, and major businesses. One of the first major shopping centers of the East Bay, the Broadway Shopping Center, opened in 1951, providing 38 stores.

Between the 1920s and 1950s, Walnut Creek was an important center of California's agriculture. Principal crops were pears, walnuts, and exceptional grazing land for cattle. In more recent years, the main sources of employment include Longs Drug Stores, John Muir Medical Center, Kaiser Permanente Medical Center, *Contra Costa Times*, and Target.

In September 1953, Kaiser Hospital opened with 76 beds for both member and non-member patients. Patients' demands outgrew the hospital, and non-member patients and their independent doctors encouraged construction of a new hospital called John Muir Memorial Hospital. Construction began on April 8, 1963, and opened to serve the surrounding communities in April 1965. The hospital was the first "high-rise" building in Walnut Creek.

Walnut Creek grew from the 1960s through the 1990s into a regional cultural center with various museums, art galleries, and the Lesher Center for the Performing Arts. By the 1990s, the hamlet was a thriving city, a central location of community, business, and medical care for Contra Costa County.

October 21, 1914, was an important date for Walnut Creek. It was the day of incorporation, establishing the town as the eighth city in Contra Costa County. Harry Spencer, owner of the lumber and building supply store, was elected president of the city's new five-member board of trustees, later to become the city council. At this time, Walnut Creek was called "the Gateway to Contra Costa County" and was incorporated a city of the sixth class. The population was upward of 750.

A new flagpole was raised on July 4, 1917. It was another important event for citizens. They gathered at the corner of Mount Diablo Boulevard and Main Street, looking west. Excerpts of early trustees' meetings include an entry on November 1915. Trustees approved expenditures for the construction of a flagpole at the intersection of Main Street and Mount Diablo Boulevard.

Another view of the raising of the flagpole is shown here. The crowd on Main Street included children with drums and members of the American Legion. Note the building in the center of the photograph is the ever-present Rogers Hotel.

Pictured around 1920 at the center right is one of the most imposing structures in town. It is the First National Bank building constructed in 1913 by R. N. Burgess, who later developed the Lakewood Estates subdivision. The varied business activities housed in substantial and modern buildings lining both sides of Main Street, the chief thoroughfare of the community, are further testimony to the prosperity of the town and the tributary county. Among the leading structures to be listed are the First National Bank, the W. S. Burpee block, and the Grimes and Nottingham building. Walnut Creek is municipally well directed, with low taxation. It is provided with a modern sewerage system and supplied with the finest water by a well-equipped plant of the latest design.

This is the second bank to serve Walnut Creek in the early days. Pictured above on the far right (next to the Rogers Hotel) is the San Ramon Valley Bank. It sat at the southeast corner of Main and Duncan Streets. This is considered Walnut Creek's first official financial institution, constructed in 1907. Prior to establishment of this bank, Joseph Silveira, proprietor of the Valley Mercantile Company, had been conducting a small banking business in his offices. By 1907, he realized this style of banking was inadequate for the growing village. After contacting several successful businessmen, the San Ramon Valley Bank opened in June 1907. The San Ramon Valley Bank sold its interests to the Bank of Italy, which has since become the Bank of America.

Above is a closer look at the San Ramon Valley Bank built in 1917. Next to it stood the Justice Court Building. It housed the office of the justice of the peace, Capt. George A. Duncan. It is of historical note that it was here that the Walnut Creek Businessmen's Association met and prepared plans for the city's incorporation.

On May 16, 1914, the enduring Rogers Hotel is the site of a rotary club gathering. Quite a festive group is pictured above, ready to enjoy a day of camaraderie in Walnut Creek. In later years, Walnut Creek's Rotary Club was an important part of community participation. The mission of the club was to encourage and foster the ideal of service.

The gentlemen walking on the sidewalk on the right seems unperturbed by the dirt and dust to his right. During the early 1900s, Walnut Creek was reported as not even having a stop sign or service station. Of course, that all changed with the popularity of the automobile. Slowly, as horses were replaced, it became clear to citizens that paved roadways were far more preferable than dusty dirt roads.

What could be better than paved streets? Possibly the marvelous illuminated welcome sign erected on Main Street near Cypress Street in 1923. It read "Walnut Creek" and had 115 small electric lights. Probably just as wonderful was the scent of freshly baked bread from the nearby Selleck's Bakery store.

Pictured above are three men standing in front of the Bradley Brothers Soda Fountain, the meeting place for many a child and family during the 1920s. The brothers opened the first telephone exchange in Walnut Creek in the rear of their store. It had 40 sockets. By 1919, operators handled 78 customers. After World War II, there were 1,140 telephones in town. By 1950, that number had risen to 4,669, and a big jump up to 20,264 in 1964. This dramatic increase was a sign the city was growing and thriving.

No one could be happier with the paved roadway than owners and patrons of businesses. Standing here in the Valley Mercantile fancy wear department, employees pose for the camera knowing the dust from the road will no longer mar their fancy wear. Joseph Silveira constructed the brick Valley Mercantile building at Main and Cypress Streets in 1916. Joseph became a businessman at a young age. His property had a dock where customers could load their wagons, and next to that was a horse trough. He even had a well at both his house and store.

Employees of the Fred Freitas Hardware store in the Stow Building are shown enjoying a moment in the sun. Streets and sidewalks are clean and neat, welcoming customers. James Stow had constructed the building, one of the newer commercial structures at that time. Stow was a county supervisor in 1900 when the officials of Contra Costa and Alameda Counties voted to build a tunnel through the Berkeley hills.

In the early days, the Walnut Creek Hotel was called Pyne's Rooming House (sometimes spelled "Pine"). In the 1930s, the building looked like this, and was just north of the old town hall. The ground floor of the Walnut Creek Hotel contained the kitchen and dining room. Rooms on the second floor were rented. The Costaldos later owned the establishment. It became known for delicious meals. The boardinghouse at 1517–1521 North Main Street served the growing number of construction crews drawn to the town by utility work when the Pacific Gas and Electric Company and the telephone company brought service to the area. Al Peronetto bought out the Costaldos and operated the hotel for 18 years. After construction of the Caldecott Tunnel in the mid-1930s, fewer people needed hotel rooms for overnight stays as the east-to-west ride became so short.

Employees of the Walnut Creek Cannery assembled for a photograph in 1920. As fruit crops flourished on land around Walnut Creek, canning became a successful venture. Later large orchards of walnut and almond trees were planted.

Five women and three boxes of pears are assembled above, in 1922, in a local pear orchard during the pear harvest season.

The Mount Diablo High School District was formed in 1901. The district included Walnut Creek, Concord, Clayton, Moraga, Lafayette, Bay Point, and Pleasant Hill. The 1920s and 1930s brought further improvements to the area's school district. The Oakland-Antioch Railway provided a train for students called the *Toonerville Trolley*. This service increased attendance, with records indicating 363 students attended in 1932. Above is the grammar school in Walnut Creek as it appeared in 1928. It was located between Broadway Plaza and Botelho Drive, west of Main Street, on the same site as the older school before it.

When not in school, children and their parents attended the El Rey Theatre. On this day, October 6, 1938, *Love Finds Andy Hardy* with Mickey Rooney and *Gateway* with Don Ameche were playing, as indicated on the marquee. The theater was opened, to the delight of residents, on July 30, 1937. It was designed in the art deco style popular at the time and had air-conditioning. The Ramona Theatre was just down the street. Next to the El Rey Theatre was the El Rey Market. Note the two signs at the lower right, in front of the market, which read Highway 21 and Highway 24. Main Street was officially the main thoroughfare connecting east and west. The second photograph is Main Street looking north. The building on the right was the First National Bank. A sign next to it reads "soda," referring to the Bradley Brothers Soda Fountain.

Let's not forget the advent of electricity. Next to the tree on the right is the Pacific Gas and Electric office in the 1920s. Electrical service began in the autumn of 1910. The December 5, 1910, edition of the *Daily Gazette* read, "The Stow Brothers are being kept busy wiring houses for electric lights." Across the street, one can see the sign for the Colonial Inn offering rooms and a café. The inn was in the original Rogers Hotel building, which was on Main and Duncan Streets. Telephone service was brought into Walnut Creek, Martinez, Pacheco, and Alamo in 1881 by the Sunset Telephone Company. The first telephone belonged to G. W. Geary in 1910.

What better way to announce the news in the mid-1920s but with the *Contra Costa Courier*, whose office is pictured above next to the Ramona Theatre on Main Street at Trinity Avenue. The first edition of the newspaper was published in May 1911. Historic notes of the time describe the *Contra Costa Courier* as "newsy, alert, and of extended circulation." It was owned by Col. William L. White and managed by Francis H. Robinson, who was assisted in the news department by Lyman E. Stoddard. The *Courier* later merged with the *Danville Journal*. Walnut Creek's first movie theater was the Ramona Theatre, pictured on the right. It opened in 1920. Here it is showing *What's Your Hurry*, with Wallace Reid playing the character Dusty Rhoades. Also showing is *Go and Get It*, directed by Marshall Neilan. It is reported that Native American artifacts were uncovered during construction of this building.

Here are bright lights in the big city; Walnut Creek is shown at night around 1950. The Western 5-10-15 Cent Store looks closed down for the night, but next door is a brightly lit Coffee Bar advertising dinners on its sign. The photographer would have been standing on Main Street looking north near the corner of what is today Mount Diablo Boulevard.

Quite an impressive sight is this photograph of the October 1947 Walnut Festival Parade. Proudly trotting down Main Street is the Martinez Horsemen Association. They are in front of the El Curtola Restaurant, which occupied, underneath a new veneer, the Rogers Hotel. This is looking south to Walker (later Duncan) Street, and just down a bit is the Bank of America.

Farry Granzotto became mayor of Walnut Creek in 1959. Here is Farry's tank truck on June 20, 1939. And below is the Granzotto truck in the October 6, 1947, Walnut Festival Parade. It is transporting the queen's float down Main Street in front of the Food Spot Delicatessen, where the sign in the front window clearly states they are "open to-day" ready and eager to serve refreshments to enthusiastic crowds.

Here is the new California Boulevard on May 7, 1967. Another majestic oak tree decorates the roadway at the building where Jack Tait had a shop at the west end of Cypress Street. The new California Boulevard replaces the Sacramento Northern Railroad tracks. California Boulevard has since become a main road through the city. There is now a north and south California Boulevard taking citizens past attractions like the Lesher Center for the Performing Arts.

Pictured at left is the 1950s Walnut Festival Parade version of the queen's float. A bit more elaborate than prior years, it captivates the throngs of people lining the street.

In 1950, a footrace on Civic Drive was added to the parade festivities. That is a glorious old oak tree behind racers Nos. 3 and 13. Next to the tree is the Walnut Creek City Hall.

Here is a closer look at city hall, which stood on Civic Drive near Broadway. The present-day city hall and police station can be found near this location on North Main Street and Broadway. Walnut Creek has a city council form of government. There are five city council members. They are elected at large for four-year, staggered terms; elections are held in November of each even-numbered year. City council meetings are held the first and third Tuesday of each month at 7:00 p.m. in the council chamber at city hall. All council meetings are televised live.

It wasn't all festivals and parades in the 1950s. The day of the flood came on April 2, 1958. The creeks in the Walnut Creek area overflowed their banks. These are shops flooded with water on the south side of Broadway Plaza. The San Ramon and Walnut Creeks were beyond their capacity as torrential rains fell all day. Four hundred families were forced from nearby homes. The very creek that lends its charm and name to the city had a bad few days. The chosen solution to future flooding concerns was to build a series of canals. These canals are now adjacent to peaceful walking and biking trails.

Three

NEIGHBORHOODS, RESIDENCES, AND RECREATION

At the core of Walnut Creek were, and continue to be today, quality neighborhoods. Chapter three will explore several historic areas, including the Woodlands, the Lakewood District, Rancho San Miguel, and Rossmoor.

The first group of immigrants to arrive at the Corners in 1841 built cabins along what was then called Nuts Creek. This could be considered the first neighborhood, located in the area currently near Mount Diablo Boulevard and Broadway. There were many unroofed shacks along Nuts Creek in 1847, and at that time, William Slusher built the first roofed house at Mount Diablo Boulevard and Broadway.

Lakewood was considered the finest Walnut Creek subdivision during the 20th century and was developed by Robert Noble Burgess. From a young age, Robert Burgess had a way with business and finance. Toward the end of his life, Burgess developed the Lakewood Estates. In 1908, his company bought the 1,750-acre William Rice ranch, which became the Lakewood Estates, east of Homestead Avenue.

Rossmoor came about when R. Stanley Dollar purchased land in the area in 1930 and lived on that land along with his son R. Stanley Dollar Jr. Stanley Dollar Jr. sold the estate to successful land developer Ross Cortese. Under the name Leisure World, Cortese had built private communities in Maryland, Long Beach, and Laguna Hills. His company was called the Rossmoor Corporation. On February 27, 1964, he opened Walnut Creek Rossmoor Leisure World and only sold homes to persons over 52. In 1973, the Golden Rain Foundation obtained the title to all the communities' facilities at what is now called Rossmoor.

Parks and open space are near every neighborhood. Recreational opportunities include hiking and biking trails of every description, several public pools, picnic areas, garden centers, and a widely acclaimed city recreation department. Every year, the much anticipated Walnut Festival contributes donations to neighborhood programs. A recent check of the multiple-listing real estate service for Walnut Creek indicated 33 neighborhoods, including Rancho San Miguel, Scottsdale, Rudgear Estates, and Walnut Heights. Walnut Creek's neighborhood homes have a wide range of styles.

In the early days, numerous residences were clustered in what is now considered the business district of Walnut Creek. The Botelho property above is one of those. Antonio S. Botelho came to the hamlet in the 1870s. He purchased the L. G. Peel farm, which ran south of Las Trampas Creek. In 1882, he bought a run-down hotel on a strip of land that was later named Botelho's Island. This so-called island ran south between two creeks, Las Trampas and San Ramon. Today most of Broadway Plaza Shopping Center is on Botelho's Island.

The old Botelho home, originally built as a hotel in the late 1860s, looked like this in the mid-1940s. It was located on the east side of South Main Street over the creek about where Capwell's parking lot stood in 1973. This picture was taken facing northwest. The creek can be seen in the background along with South Main Street.

50

This was originally the home of James R. McDonald, constructed in 1868 on Locust Street adjacent to the Firestone Building. Note the large locust tree in front of the house. In the beginning, Main Street and Locust Street were the site for a number of homes; thus, the area was one of the first neighborhoods of Walnut Creek. James R. McDonald was appointed the Walnut Creek postmaster on December 1, 1862.

Information on this photograph states this is the Oakshade Villa in Walnut Creek, quite a Norman Rockwell moment. Pictured from left to right are Mary Jane Whitcomb Hodges Weston, Levice Hodges Biggs, Emma Biggs Chastain, Arlene Biggs, and Frank E. Weston. A. D. Biggs was elected one of the two first elders of the Presbyterian church in 1878.

Here is another view of the Cameron home on Locust Street in the mid-1800s. The Cameron blacksmith shop was on Main Street near Mount Diablo Boulevard. Other businesses and neighbors of Cameron were the Sherburne Brothers Store, Pierson's Emporium, the Methodist church, Kimball's Tin Shop, and the Thomas J. Young store. In 1909, the village of Walnut Creek had approximately 25 businesses on Main Street according to the county assessor's map. The map lists the business establishments as one hotel, one livery stable, one baker, one shoe shop, one meat market, one ice cream parlor, one undertaking parlor, one barbershop, one watchmaker's repair shop, one tine shop, two drugstores, two harness shops, two garages, two plumbing shops, two mercantile stores, one greengrocer, one variety store, two saloons, and three blacksmith shops. The owners of these establishments decided an organization was needed to promote growth in the small hamlet. A committee was formed that included Angus Cameron, and the outcome was the Walnut Creek Businessmen's Association. It was this organization that, in 1912, began the process for incorporation of the City of Walnut Creek.

The Angus G. Cameron home on the northeast corner of Cypress and Locust Streets is pictured here in 1895. From left to right are Elmer Cameron, Angus Jr., Duncan Cameron, and Mrs. Cameron. Elmer was a blacksmith. Angus was a blacksmith, harness maker, and carriage maker.

This is the John Baker home at the south end of Walnut Creek. In August 1913, Main Street was the location of the Baker Building, now 1511 Main Street. In January 1912, the Baker Building, having been vacant for nearly a year, was rented for $12 a month by the Walnut Creek Women's Club. Their goal was to establish a library in the village of Walnut Creek. That was the beginning of the library system in Walnut Creek.

The photograph is of the Johnnie Walker residence. Johnnie's father, James T. Walker, was a nephew of the early explorer and guide, Capt. Joe R. Walker. The original Walker property was the Sulphur Springs Sanatorium and Ranch. The Sulphur Springs Ranch was near Ygnacio Valley Road near Heather Farms and the Bancroft home and orchards around 1890. As the story goes, Johnnie's mare foaled every year at the ranch. Unfortunately, mountain lions would often claim it until, one year, Walker stayed with the young horse, protecting it, and as the story goes, this was the palomino he rode in the first Walnut Festival Parade. The name of the beloved horse was Don Juan.

Michael Kirsch was a German who immigrated to Walnut Creek in 1845; pictured here is the Kirsch residence. He was an iron worker and blacksmith by trade and became one of the hamlet's first blacksmiths. An advertisement from the *Walnut Creek Independent* newspaper of Friday, June 9, 1882, read, "Michael Kirsch, blacksmith and wheelwright cor. Main and Danville Road. Wagons repaired and new ones made to order."

This image of Main Street in 1895 looking south from a point in front of the Rogers Hotel shows the home of Michael Kirsch and his shop. Elevated tanks supplied a reserve for water in the early days.

This is the c. 1900 Spaite ranch, formerly the Welch property at Walden and Contra Costa Highway. The first immigrant wagon train came into the Walnut Creek area on November 2, 1841. On the log of the wagon master appeared the name of William Welch among 14 other men and families. In 1832, Welch petitioned the Mexican government for a rancho and was given Rancho San Miguel. This property extended from a point 250 yards south of the present Rudgear Road.

The city of Walnut Creek is viewed here around 1914 from Terrace Road looking east. The prominent dirt road left of center is Almond Avenue. Almond was later named Walnut and later still Trinity Avenue. This view certainly captured Walnut Creek's scenic open space in the early 1900s.

This was the James Foster home. The Foster home was built in 1866, located on a hill between Locust Street and California Boulevard near Civic Drive. James came to Northern California from Maine in 1857. The Foster family lived in this house until 1891 when he died, and the house was purchased by the widow of James T. Walker and her daughter Louise.

The photograph above was taken on September 30, 1947. This property had several owners after it was first built by a Mr. Dodge around 1900. At different times, it was the property of the Goodman family in 1910, the Newell family, and the Counter family. The Newells had purchased the property in 1922. Theodore Newell grew pears, prunes, irises, and mums in his orchard and gardens.

57

In 1941, Newell sold this home and acreage to Mr. and Mrs. Edward Counter. Mrs. Counter used the house for luncheons, dances, banquets, and lectures. She named the site the Walnut Creek Art and Garden Center. There was an art gallery, a ceramic studio, jewelry store, and yarn shop. The Art and Garden Center became the center of culture in the 1940s. This Counter property had originally been a 10-acre ranch along South Main and Newell Streets and is now occupied by Kaiser Hospital. In the early 1950s, industrialist Henry Kaiser noticed the lack of hospital care in the Walnut Creek area. He chose this property, then owned by Counter, to construct a hospital.

The Walnut Creek area is home to churches of all faiths. Early churches that were established back when the village was incorporated into a city were meeting places where both men and women found fellowship and community. Catholics, Methodists, Presbyterians, Christian Scientists, and Episcopalians maintained congregations. This photograph is of St. Paul's Mission Chapel on School Street (now Locust Street), between Trinity Avenue and Bonanza Street in 1925. It was built in 1889 by Cornelius Waite. This redwood chapel was moved in 1950 to its present site. Episcopalians met in a schoolhouse in August 1887 to raise money to purchase a church site. In 1888, $175 was raised to purchase the lot on Locust Street. The story goes that this money was raised by church members traveling via horse and buggy from house to house selling homemade jams and preserves and by holding bazaars. Construction began in November 1889 at a total cost of $1,600. The church did not have a resident minister until 1944, so until September of that year, it continued to be a mission. At that time, the first vicar took his position. The church was moved to a new site on Trinity Avenue on October 20, 1950, so it might be preserved.

The Presbyterian church on Locust Street was constructed in 1884. Construction of this church came about when, in 1878, a group of citizens met at the home of Phoebe Webb and discussed establishing a Presbyterian church in the village. The first services were held in June 1878 in a nearby schoolhouse and were held there until 1884, when a lot was purchased and a church was constructed on Locust Street. In later years, this church was called the Oakland Boulevard Presbyterian Church.

This photograph is of the Methodist church as it appeared in the late 1940s on the west side of Locust Street approximately 150 feet north of Mount Diablo Boulevard. Originally it was built in 1872 on the west side of Main Street on the site of the Stow Building; it was moved to Locust Street in 1911.

The residence of William C. Prince is drawn in the image above. This view is looking down on Pacheco Road (now called Oak Grove Road) approximately where Citrus Avenue is today. Ygnacio Valley Road and Shell Ridge are beyond. Back in this era, there were daily stagecoaches running from Woodlands to the Delta that followed a very dusty and sometimes very muddy Ygnacio Valley Road right past where the Woodlands Cabana Club is located today. Looking at the etching, one can imagine livestock grazing at Valle Verde Elementary School, as well as right on one's own lawn. In the 1850s and 1860s, the area known as the Woodlands was mostly farmland. In 1961 and 1962, housing development came to the area, and once developers planned the community, the farmland changed into a desirable suburban neighborhood.

The valley known as Tice Valley originally had Native Americans in residence. Later it was home to Innocencio Romero and his wife, Incarnacion. They built an adobe near the entrance of today's Rossmoor. In the mid-1800s, this area was called Rancho El Sobrante de San Ramon, approximately 22,166 acres from San Ramon Creek to Moraga. This is a view of Tice Valley with the Dollar Ranch barn at the entrance of what is now Rossmoor. The Rossmoor community can be seen in the background on gently rolling hills. Tice Valley Boulevard was named for the Tice family who owned property here in the late 1840s. This boulevard leads to the entrance of Rossmoor. R. Stanley Dollar, the San Francisco shipping magnate, bought the ranch from the Naphtaly family in February 1932. Dollar took out the orchards and vineyards and began raising cows and horses. The Dollars bred purebred Herefords and raised show horses. Over time, their estate grew from 1,436 acres to 2,200.

This is the Dollar barn years later at the entrance to Rossmoor. R. Stanley Dollar Jr. sold his large estate to Ross Cortese in 1960. Cortese was in his 40s, a successful land developer from Glendale. Cortese's plan was to create his best retirement development in Walnut Creek. His prior successes included the Leisure World private communities in Maryland, Long Beach, Seal Beach, and Laguna Hills. He named his Walnut Creek company the Rossmoor Corporation. Cortese began construction in 1963 and opened the Walnut Creek Rossmoor Leisure World on February 27, 1964.

Above is a view of the John and Martha Jones ranch and home surrounded by farmland. John, Martha, and their young son Henry headed west from Illinois in 1851. What a wonderful sight the Diablo Valley must have been for weary travelers. It was described as possessing "a climate that is not surpassed by any section of California, and its scenic features, encompassed as it is by the foothills that buttress Mount Diablo, are attractions of more than ordinary note."

When John, Martha, and little Henry arrived in the area now called Saranap, they purchased 310 acres of land and built a two-story farmhouse of wood surrounded by fields of grain and cattle grazing land. The road to the property was off the present Mount Diablo Boulevard.

Historical information regarding local Native American inhabitants of the Walnut Creek area indicates Bay Miwok Indians lived throughout Contra Costa County in small tribal villages along the creeks. One Saklan settlement was archeologically excavated near Rossmoor Parkway, and more remnants were found in Saranap.

The area named Saranap is currently in an unincorporated portion of Contra Costa County. However, it is in and about and adjacent to Walnut Creek proper and played an integral part, and still does, in the development of the city of Walnut Creek. It lies just south of Rossmoor. The name Saranap was created by Joseph and Sara Naphtaly, landowners in the area in the 1800s. They combined Sarah's first and last names. Early landowners included the Kerlinger family. Pictured above is the Kerlinger ranch.

65

Early landowners around and about Saranap included the Volz family. Pictured here is the Volz home and ranch in 1924 on Alder Street. Village and Alder Streets were near each other, clustered around the Sacramento Northern Railroad tracks crossing Tice Valley Boulevard. That right-of-way is now called Olympic Boulevard. Quoting from subdivision fliers in 1913, property in the area is described as follows: "Beautiful home sites . . . No suburb of the Bay Cities appeals stronger to the home seeker than the Mount Diablo Country with its wooded ravines, oak covered dells and broad valleys of sediment soil, with pure air and sweet water and natural beauties unsurpassed in the State of California."

Pictured above are eight fashionably dressed ladies of the Saranap Women's Club posing on a porch around 1910. The charming neighborhood of Saranap began where Boulevard Way took off from Mount Diablo Boulevard.

Pictured is a Saranap woman with a musical instrument, on which it reads "Saranap jass [could be jazz] orkester." Records indicate life in early Saranap was quite different than it is today, true of most communities in the United States. Physical labor of farm work and household chores usually required an early bedtime. Families enjoyed simple evening amusements such as storytelling, reading, and making their own music.

67

This delightful brochure was prepared by the Walnut Creek Area Chamber of Commerce in cooperation with the City of Walnut Creek in the mid-1950s. It describes Walnut Creek as "paradise in a nut shell." The welcoming brochure goes on to present the "Bay Area bright spot" as follows: "Walnut Creek, California is located at the hub of the rapidly expanding Central Contra Costa County area just 25 miles east of San Francisco."

Walnut Creek is considered by many as a prime residential area. A good example of a typical Walnut Creek neighborhood is Palos Verdes Estates. Constructed in the 1960s, these ranch-style residences were available in five floor plans. Even the names for layouts were distinctively Californian: the Carmel, Santa Inez, Monterey, Capistrano, and the San Carlos. (Photograph by Catherine Accardi.)

Pictured above is the Rice home on Hacienda Drive as it appeared in the 1920s. It was built in 1886 on the site of the Sibrian adobe. The boundaries of the Lakewood District neighborhood in Walnut Creek are approximately Marshal Drive to the north, Walnut Boulevard on the south, Shell Ridge Open Space on the east, and Ygnacio Valley Boulevard on the west. The earliest known residents of the Lakewood area were the Bolbones Indians. The first recorded owner of land in Lakewood was Dona Juana Sanchez de Pacheco. Ygnacio Sibrian, Dona Juana's grandson, and Dona Juana were the first permanent residents of the area. Ygnacio's home was an adobe hacienda, built in 1836. Ygnacio sold his home in 1860 to William Rice, who bought 1,516 acres for $15,000.

This photograph of the Rice residence, later the Burgess residence, was taken in 1916. William Rice and his family lived here and farmed the land until 1908, when the parcel was sold to neighbor Robert Noble Burgess for $75,000. When Burgess subdivided his acreage, the subdivision brochure for this area, the Lakewood District, was titled "Walnut Creek-Suburban Homes." It listed John Promberger as the sales manager for the R. N. Burgess Company at 734 Market Street, San Francisco, California. The brochure went on to read: "These beautiful homes will be within thirty to forty minutes from Oakland, and the trip from the bay, on the Oakland and Antioch Electric Railroad will give one the most wonderful panoramic view to be seen in all the West, in fact in any spot in the wide world."

The Lakewood District, pictured here around 1937, reveals a peaceful scene with a quaint cottage surrounded by lovely trees and rolling hills. This subdivision was the inspiration of Robert Noble Burgess, a young farm manager turned real estate speculator and developer. Burgess grew up on his father's hog farm in Danville. Later he became a successful landowner and developer in Oakland, Diablo, San Francisco, and eventually Walnut Creek. He formed the R. N. Burgess Mortgage Company, and in 1908, he purchased the William Rice Ranch for $45 an acre. Burgess married Anne Fish in 1909. Anne furnished the old Rice home on their 1,750-acre parcel, which they named Homestead. During the following years, there were ups and downs in Burgess's business transactions until in the 1930s he subdivided his homestead acres into 250 building sites. After World War II, people moved to Walnut Creek in large numbers, lots sold well, and the Lakewood District was a success. It is still one of Walnut Creek's most delightful neighborhoods.

Pictured is the Lakewood guesthouse, also known as the clubhouse. The clubhouse was designed by the famous Berkeley architect Julia Morgan and was built by the dam at the north end of the lake. There were accommodations for guests, and a housekeeper was available. Swimming and fishing were available on the lake, which was stocked with fish.

Another view shows the Lakewood area with two homes on a hill overlooking the peaceful lake setting. The Lakewood properties are now maintained and administered by a 52-member/owner Lakewood Association. After World War II, Burgess subdivided his walnut grove in the lowlands into two tracts: Lakewood Village in 1940 and Homestead Ranch in 1945.

This is the former Burgess house on Hacienda Street as it stands today. Originally constructed in 1886, it was renovated in 1987 and has seven rooms on two floors. The house is said to have nine basements, the result of additions through the years. For a time, the house was known as the Mansion Inn at Lakewood and was opened as a bed-and-breakfast inn. The inn has since closed. The house is now a private residence. (Photograph by Catherine Accardi.)

Plenty of open space allowed for delightful picnics from the beginning, as pictured here where a group of people enjoy a day out in the sun, perhaps a hike on the lovely hillsides, or a leisurely drive on the gently winding roads. (Courtesy of Peter Hjersman.)

Castle Rock Park is adjacent to Diablo Foothills, located in a scenic canyon along Pine Creek. The area is dominated by oak woodlands and prominent sandstone formations. Besides Diablo Foothills, Castle Rock Park is bordered by Mount Diablo State Park and the Walnut Creek Open Space, providing access to more than 18,000 acres of public lands.

The pool at Castle Rock Park is seen in the early days. Today the pool complex features a 30-by-70-foot swimming pool and deck areas. Volleyball courts, softball fields, and picnic site are now open to the public on a daily basis. The earliest known swimming pool was the one at the Charles Howard home on Walnut Boulevard, where it is said many schoolchildren would gather on hot days.

The baseball diamond at North Main and Lacassie Streets was built for the town team games. This is a photograph taken at a 1911 baseball game between Walnut Creek and Cowell.

As the story goes, in 1954, several Walnut Creek teenagers received motor scooters, known as doodlebugs, from their parents, and that is where the 24-member drill team known as the Walnut Creek Doodlebug Club began. A police officer would teach them maneuvers used by the Oakland police team. As the team grew, they moved to a larger area at Buchanan Field to practice.

This is a 1925 photograph of the Walnut Creek Boy Scout Troop practicing first aid on a fellow Scout. By the 1920s, Scouting had taken hold in Walnut Creek. In 1925, sponsors included the Walnut Creek Lions Club and Post 115 of the American Legion. Both the Boy Scouts and Girl Scouts continue their tradition of community service to this day.

The annual Walnut Festival is an important annual fund-raising event for Walnut Creek. This is a view of the festival at night. The event is responsible for thousands of dollars in donations for the community. In the past, the festival has been held on the grounds of Heather Farm. Pictured here are glowing lights, carnival rides, and plenty of fun, food, and activities for the whole family.

Four

TUNNELS, TRAINS, AND MORE

Transportation was vital to Walnut Creek from the earliest days. Chapter four will focus on the early days of the Corners, a junction of four dirt roads, evolving into a stagecoach stop, railway center, then into Highway 24 and Interstate 680.

In the beginning, the typical modes of transportation were walking, horses, carriages, or stagecoach. The first stage line began in 1850 from Martinez to the Walnut Creek House then on to Lafayette and Oakland. By 1885, the village was an important stage line stop on the way west to Oakland.

The year 1877 brought the first public meetings to consider building a tunnel through the Berkeley/Oakland hills. *Walnut Creek, Arroyo de las Nueces* by George Emanuels reads, "The main purpose of the road and tunnel is to bring the trade of a large and productive portion of Contra Costa County to Oakland." Alameda and Contra Costa Counties agreed to the plan. This extraordinary decision would eventually bring exponential growth to Walnut Creek.

Walnut Creek was one of the first East Bay cities to receive Southern Pacific Railroad service on June 7, 1891. It was in 1901 that the Walnut Creek train station was built. Freshly baked bread, at 5¢ a loaf, came to Walnut Creek on the first train every morning as grocers drove their wagons to the station to pick up wooden crates shipped by the Langendorf Baking Company in Oakland. The Southern Pacific passenger train between Walnut Creek and San Francisco in 1910 was a relatively comfortable two-hour ride, as shoppers could leave the town on the early train, arrive in San Francisco around 9:00 a.m., spend the day shopping and dining, then leave by the 4:00 p.m. train arriving back home at 6:30.

Electric trains were run by the Oakland, Antioch, and Eastern Railway Company, which became the San Francisco–Sacramento Railway and the Sacramento Northern. Passengers from Walnut Creek went directly into San Francisco over the lower deck of the Bay Bridge from January 1939 until June 1941. Most freight service was dropped by 1958. The Highway 24/Interstate 680 Interchange solidified a high level of transportation service to Walnut Creek with its opening in March 1960. The city's first Bay Area Rapid Transit (BART) station opened on May 21, 1973, thus continuing Walnut Creek's long-standing position as a center of agriculture, business, and commerce.

In the beginning, modes of transportation were feet, horses, carriages, and stagecoaches. In 1850, when the first settlers arrived at the Corners, they traveled by wagons drawn by oxen, wooden wheeled carts with mules or horses, on horseback, or on foot. In the 1850s, Walnut Creek, or the Corners, as it was known then, found a place on the map. At this time, the area was known as the Corners because it was the crossroads of several important roadways between Stockton and Oakland to the west, Martinez to the north, and Livermore to the southeast. The Corners changed its name in recognition of it being the habitat of the black walnut. Pictured above is the stage line arriving from Lafayette in 1893.

Pictured here is the Cameron Harness Shop on Main Street in 1914. Elmer Cameron is on the left. Of course, the horse was a principal form of transportation in the early days. It was in 1868 that the Morris brothers blazed a trail and opened a stage line between Oakland and Clayton via the Fish Ranch Road.

Elmer Cameron is pausing and posing while working on a horseshoe in this blacksmith shop. In 1859, W. H. Sears built a stable known as the Sears Livery Stable on the east side of Main Street. Sears rented out saddle horses, carriage horses, or teams. Rental per horse without saddle (saddle was furnished by customer) was $5 and with saddle $10, for 10 hours. A buggy with one horse was 50¢ per hour; a surrey with team was $1 per hour.

Driving through the Caldecott Tunnel today, it is difficult to imagine that back in the 1860s it took more than two hours to travel by stagecoach from Lafayette to Oakland. Originally the road over the hills was called Summit Road; then in the late 1850s, it was changed to Telegraph Road when the new telegraph line to Antioch was strung from poles at the summit. The beautiful horse and buggy in this photograph are on Tunnel Road, and quite a pretty scene it is. The slow ride over Telegraph Road was a deterrent to the single horse–drawn vehicle until 1903, when a tunnel was drilled through the Berkeley Hills. This first tunnel, some 200 feet above the current Caldecott Tunnel, was sufficient for slow-moving horse-drawn vehicles. The new tunnel allowed loaded wagons, rather than driving over the Moraga road through the town of Canyon, to shorten the trip to Walnut Creek by over 3 miles and save 320 feet of climbing.

Let's not forget transportation via foot power. Pictured is Railroad Avenue (now called Duncan) and the wooden bridge across Walnut Creek in 1901. In the distance are the Rogers Hotel and a wagon next to it. This bridge was later moved to South Main Street near Quail Court. The wooden path on the left appears to be a foot and bicycle path.

Local residents recall stories of family members who worked on the old tunnel in the early 1900s. According to these accounts, the mother packed up the wagon with the children, bedding, tents, and supplies and drove to Orinda to a nearby ranch where work was to begin on excavating the tunnel.

The Canary Cottage Roadhouse was a popular place for travelers at the east end of the bore of the high-level tunnel. It sold soft drinks and sandwiches, so travelers took advantage of services provided by the proprietors. In those days, the trek over the hills, prior to the opening of the first tunnel, was long and arduous, taking several days. Travelers could enjoy meals and overnight accommodations before continuing their journey the next day. Note the snow on and around the cottage in the January 29, 1922, photograph above.

This gentleman, leaning against his jazzy vehicle, has taken a break from the dusty drive on Tunnel Road. He is probably enjoying the stop at the Canary Cottage. But before the days of such automobiles, and before the tunnel was improved, the dark and narrow one-way tunnel was a challenge to wagon drivers. They had to light up newspapers when entering to signal to those at the other end to wait. And so it went until 1925. When the Canary Cottage finally received electricity, it was given to the proprietor for free if he agreed to replace burned-out light globes in the tunnel. He would climb on top of a wagon loaded high with hay, reach up, and replace the bulb. Walnut Creek was a business center, even in its early days, so it was of particular importance to the City of Walnut Creek to improve access to its thriving downtown businesses via the tunnels.

With the new transportation option, thousands of people sold their Oakland and Berkeley homes and moved east into the Walnut Creek area. Pictured above is c. 1915 traffic at the tunnel. Note the woman on the right of the tunnel entrance standing by the side of the road in a dress and bonnet. This might not have been the safest thing to do as recounted in an article appearing in the June 23, 1911, *Contra Costa Gazette*: "At 2 o'clock on Thursday, June 22, 1911, a masked gunman forced Frank McClane out of his automobile as he approached the intercity tunnel. The highwayman forced him to stand at the side of the road while he searched McClane's pockets and took his watch and small change. The man told his victim to drive on and not look back as he disappeared in the brush. This is the second affair of the kind in this area." The increase in population and the increasing popularity of the automobile rendered this tunnel inadequate by the late 1920s. In 1929, construction of the first two bores of the Caldecott Tunnel began.

The Caldecott Tunnel was designated a landmark in 1980 and received a preservation award from the Art Deco Society of California in 1993. As can be seen in this photograph, the art deco design detail above this eastbound bore is quite artistic. The newer north bore art deco work is just painted onto the structure. The Caldecott Tunnel was named after Tom Caldecott, a supervisor in Alameda County. When the two Caldecott Tunnels opened in 1937, new residents poured through to live in the already crowded community of Walnut Creek. These tunnels became the main access between Alameda and Contra Costa Counties. During the 1950s, when the population of Contract Costa County increased by 37 percent, the need to increase the capacity of the tunnels became apparent, so in 1964, a third bore was opened north of the original two. (Photograph by Catherine Accardi.)

Back in the day, engineers located the eastern entrance of the bore on the road they named Tunnel Road, today called Old Tunnel Road. Today the site of the west bore of the old tunnel looks like this. One can just make out concrete slaps up on the hillside and can imagine the tunnel opening below. Although houses are adjacent to this site today, the actual site remains empty, covered in brush and trees. The plaque is equally forlorn and abandoned and reads, "Inter county tunnel built by Alameda County Contra Costa County and Merchants Exchange Oakland California." (Photographs by Catherine Accardi.)

Southern Pacific Railroad built this train station in 1901. Although the station was built then, Southern Pacific began train service to Walnut Creek on June 7, 1891. Before train service to Walnut Creek, Farmer Sanford, local livery stable owner, ran a stagecoach from Main and Duncan Streets near the Rogers Hotel to Orinda to meet the train there on its arrival. The Rogers Hotel advertised "our surreys meet each train." The trip from Oakland to Walnut Creek and back was a 10-hour round-trip because it stopped at every platform and station. The original station pictured above was located on the east side of San Ramón Creek and old Botelho Island, south of Walker Avenue. The big engines seen here were called the Iron Horse.

In 1910, Walnut Creek was sans the frequent, efficient electric train service that some Bay Area residents already enjoyed. This service was quite important for many citizens if they could not yet afford an automobile. Walnut Creek received its first dose of electrical power in 1910. In December 1910, the *Daily Gazette* carried the report that "the Walnut Creek Meat Market has put in electric lights and an electric motor for grinding and chopping. The Rogers Hotel is now lighted by electricity. Within the next few days the city hopes to have lights on Main Street." This excitement among residents of Walnut Creek was further increased when the Oakland and Antioch Railway began regular electric train service between Walnut Creek and Port Chicago in May 1911. When electric trains were finally able to negotiate through the Oakland hills in 1913, trains ran from Walnut Creek through the 3,600-foot tunnel, down Shafter Avenue to Fortieth Street. There it joined the Key System trains and ran out into San Francisco Bay to the ferry terminal on a mile-long pier. The boats docked at the terminal built just a half mile west of today's Bay Bridge toll plaza, where train passengers could then walk to a ferry boat for the ride to the Ferry Building. The ride from Walnut Creek to San Francisco took one hour and 10 minutes, which included the ride on the ferry.

This is the Walnut Creek Train Depot as it looked in the 1940s. This seems like a lonely scene compared to the busy glory days of the railroads. Those big engines that dominated the scene in the early days were called the Iron Horse. Nowadays, the Iron Horse hiking and biking trail occupies 22 miles of right-of-way that had been train tracks. By 1941, passenger service ended and the depot was no longer used.

When plans began for the Oakland and Antioch Railway Company, the Naphtaly family of Saranap was among a number of people recognized as incorporators of the $2-million company. When service began at the corner of Olympic and Tice Valley Roads, the train station was named Saranap.

This electric train car belonged to the Sacramento Northern. Six trains ran daily from Walnut Creek to Sacramento, four to Concord. As the story goes, the first train through Walnut Creek in the morning blew its whistle so long and loud that citizens advised the mayor to write a letter of complaint to the railroad regarding this nuisance. Time went by, and the Oakland, Antioch, and Eastern became the San Francisco–Sacramento Railway and later the Sacramento Northern. In fruit season, they carried 10 carloads of pears a day for Eastern markets. Trains also brought lumber, gasoline, and building materials. Passengers from Walnut Creek rode into San Francisco over the lower deck of the Bay Bridge from January 15, 1939, until June 30, 1941, cutting 10 minutes from the already fast service. All passenger service over the Sacramento Northern ended in 1941. Gradually the Sacramento Northern abandoned freight service in Contra Costa County as well by August 10, 1958.

Pictured above is the c. 1920 photograph of the Oakland Rotary Club visiting Walnut Creek. The Rotary clubs met at the Oakland, Antioch, and Eastern Railway station near Trinity Avenue and California Boulevard. By 1940, passenger service was terminated as the automobile became the transportation for the commuter. It was the opening of the Caldecott Tunnel that spelled the death of the train, and when the Bay Bridge opened, the commuter train was done. Greyhound buses stepped up and carried commuters and shoppers.

The automobile offered a relatively safe, clean, and fast form of transportation for residents and businesses. Pictured here is the Sellick Superior Bakery truck with bakery owner Tom Sellick in the 1920s. The Model T Ford sold for $600 to $800, and it became more and more common to see autos on city streets rather than horses and wagons.

91

With the popularity of the automobile, Walnut Creek's dusty dirt roads were a constant source of citizen complaint. The long-awaited paving of Main Street is pictured here on October 26, 1921. The project cost $57,000. A well-paved Main Street in Walnut Creek was finally a solid link in Contra Costa's Memorial Highway, dedicated in the autumn of that year.

Minutes of the board of trustees' meetings read: "August 12, 1920. Trustees approved paving Main Street with 5 inches of concrete and 1 1/2 inches of Warrenite. November 20, 1920. The trustees ordered curbs and cement sidewalks for the first time from Main and Mount Diablo to 100 feet north of Main and Bonanza." Paving work was completed by November 1921.

And then came the gas stations. The first official gas service station opened in 1920. Pictured here is the Associated Service Station at Mount Diablo Boulevard around 1930. In those days, crisply uniformed gas station attendants responded to the needs of motorists. The vehicle being tended to in the photograph has two men attending to the driver and vehicle. The round sign at the front of the station reads "certified clean comfort stations." There is even a barbershop in the rear and Club Diablo on the left, with a sign advertising food. The roadway sign in front of Club Diablo reads Highway 21. At that time, Highway 21 was one of the main roadways of the State of California Highway System.

Even at night, service stations were open and operating, as shown here with a vehicle in the service bay. Another Highway 21 sign is at the far left of the photograph. In the early days of the automobile in Walnut Creek, there were no official gas stations. As the story goes, motorists in need of gasoline pulled up in front of a garage and blew the horn, the signal for the garage mechanic to carry out his tank, wind a crank, and pump fuel into the vehicle.

Pictured here is a movement of goods via truck in 1937. This is the Contra Costa County Walnut Growers Association truck in front of the walnut warehouse on Civic Drive at California Drive. Today the Lesher Regional Center for the Performing Arts is on the property to the right. The Growers Square complex has replaced the building on the left. Nuts were quite an important crop for Walnut Creek for about 50 years. In July 30, 1917, sixty local growers agreed to deliver all their walnut crops to the Contra Costa County Walnut Growers Association, pooling the crops and hiring salesmen to sell them. A processing plant was built next to the main line of the Oakland, Antioch, and Eastern Railway in downtown Walnut Creek, on Locust Street, between Civic Drive, Cole Avenue, and California Boulevard. By 1936, this Walnut Creek plant processed 5,600 tons, and 6,600 tons in 1952. This structure was converted into a playhouse in 1967 and used until 1988, when it was removed to make way for the new Lesher Regional Center for the Performing Arts.

Improved modes of transportation did wonders for the efficiency of the fire department. This photograph is of the Walnut Creek Volunteer Fire Department in the late 1880s. From left to right are L. R. Henry Gambs, Chas Daley, Tom Ford, Chas Shermam, Valentine Ford, and Fred Kirsch. In 1883, volunteers stepped up and formed this fire department.

This is Walnut Creek's first fire station, the Central Fire Station, on the north side of Bonanza Street between Locust and Main Streets around 1937. It was built in 1926 and closed in 1965. It was the first station in the Central Fire District (today's Contra Costa Fire Protection District). What a difference there is in the manner hoses were transported during this 36-year span.

Here one clearly sees an automobile at the left of the horses. What a combination: vehicles, horses, and a wagon. The side of the wagon sports a sign that reads "The Folk Dancers." The drivers are Mr. and Mrs. Elmer Cameron. Elmer was a blacksmith with a shop on Main Street.

John Parkel (far left) is standing in front of the Union Ice Company truck alongside other employees around 1938. John is holding a chart that reads "1938 refrigerator sales." The men look happy with their accomplishments. Refrigerators were all the rage in those days. Large blocks of ice were transported to homes and businesses in trucks like this one.

In the 1920s, many people purchased automobiles, and with this rush to switch to convenient transportation came the need for motels and auto courts to serve weary motorists. Hotels were charging $5 a night, and travelers longed for less expensive accommodations. During the late 1920s, $1 lodging became available in the form of the auto court. Auto courts were a series of one-room uncarpeted cabins with an adjoining carport. One such auto court was called the White Spot in Walnut Creek. In the early 1930s, it had an owner's cottage in front and four cabins in back, later increased to 10.

Shown here is a January 19, 1946, winter scene at the corner of Homestead Avenue and Ygnacio Valley Road. A large sign at the right with an arrow pointing right reads "Lakewood." Homestead was, and still is, the main roadway into the charming Walnut Creek neighborhood called the Lakewood District. Ygnacio Valley Road was widened to four lanes in 1963 and to six lanes in 1972. Vehicle traffic increased from 11,900 trips per day in 1957 to 72,000 trips per day in 1994.

This is a c. 1948 aerial view of Walnut Creek prior to the construction of the Highway 24/Interstate 680 interchange. The interchange was built years later. This is looking east down Mount Diablo and Oakland Boulevards in the foreground. The highway system in California was one of the best in the nation.

This is a 1951 view with Highway 24 at the top; Newell Avenue and Circle Drive are in the center prior to construction of the 680/24 Interchange. With the construction of Highway 24 and Interstate 680, the designation Highway 24 was removed from Main Street.

This gathering is the March 22, 1960, opening ceremony, dedication, and ribbon cutting of the new highway bypass in Walnut Creek. Pictured in the center are Mayor Farry Granzotto and George Krueger. When the freeway was opened here in 1960, the new roadway took traffic off Main Street.

The Bay Area Rapid Transit (BART) began service in 1972, the same year the Southern Pacific Railroad depot was moved 100 feet south on Broadway and converted to a restaurant. Walnut Creek is also served by Contra Costa County Transit buses. (Photograph by Catherine Accardi.)

Five

PEOPLE, PLACES, AND EVENTS

This chapter focuses on the people and places that were the foundation of the city. Without the resourceful, energetic citizens and their families, Walnut Creek would not have the abundant resources, historic sites, and high quality of life we have today. These key people and places will be represented in historic and rare photographs. These are just a few examples.

The area known now as the Ruth Bancroft Gardens occupies land that was once part of a 400-acre farm established in the 1880s by Hubert Howe Bancroft, a famous historian and publisher. The farm remained in operation until the late 1960s. The last walnut orchard on the property was cut down in 1971. Philip Bancroft Jr. gave this land to his wife, Ruth, to plant a new garden using succulents from her large collection. These two prominent dedicated citizens have given Walnut Creek a wonderful legacy in the Ruth Bancroft Gardens.

The Lindsay Museum was founded in 1955 as the outcome of a group called the Diablo Junior Museum, whose purpose it had been to educate children about nature. It currently houses a hands-on discovery room for children. The on-site wildlife rehabilitation center is one of the oldest and largest wildlife hospitals in the United States. Alexander Lindsay was instrumental in this endeavor.

Heather Farm Gardens and Park is a California gem located in Walnut Creek. It opened as a park on July 4, 1970. The original owner of the land in the area was John Marchbanks. It originally was a horse farm and racetrack. Today there are many avid equestrians who use its arena for practice and shows. The garden and park we enjoy today was due to the efforts of several dedicated Walnut Creek citizens, including Ruth Bancroft.

The Regional Center for the Arts grand opening was in 1990, marking Walnut Creek as a cultural destination. The Regional Center houses three theaters and an art gallery. Shadelands Ranch Museum, a national landmark, opened under the management of the Walnut Creek Historical Society on November 18, 1972. In the beginning, the area now known as Shadelands was the ranch, and 1903 home, of Walnut Creek pioneer Hiram Penniman and his family.

Above is the ice truck of James Stow, loaded with palm plants for the Grape Festival. James Stow provided mail delivery service from Oakland to the east. These horse-and-buggy trips over rugged trails were difficult, so Stow applied to the U.S. Postmaster General for a post office at the Corners. Historic records indicated the reply to this request read: "No post office will be established at a place called The Corners. To have a post office a community must have a true representative name." Citizens decided this was the time to officially rename the town and voted for the name Walnut Creek because the village was situated next to a creek whose bank was lined with black walnuts. The name Walnut Creek was accepted by the postmaster general in 1871, and an official post office was opened.

Milo J. Hough of Lafayette came to the Corners in 1855 and built a hotel and store called the Walnut Creek House on a spot on Main Street near the corner of Bonanza Street. There was a bar, gambling girls, and tables where meals were served.

The three men here in front of the W. S. Burpee Billiard Room on Main Street are, from left to right, Vincent Hook, Winfield S. Burpee, and Robert ?. Winfield and Mary Sherborne Burpee were prominent citizens in the early days.

This is the Hiram Penniman family ranch house as it stood in the Ygnacio Valley. Hiram was an early Walnut Creek pioneer who built the structure in 1903. The structure was placed on the National Register of Historic Places in 1985. In the mid-1960s, local historian Isabelle Spencer Brubaker suggested the formation of a local historical society to the Walnut Creek Women's Club. The first meeting of the Walnut Creek Historical Society was on November 6, 1967.

Here are five men and a dog that has a cigar in its mouth. The men are, from left to right, W. A. Rogers, Hugh Colwell, L. A. Palmer, Charles Daley, and Joe Peters. William B. Rogers arrived in California in 1852 at the age of 23. He built the Rogers Hotel at the northeast corner of Main and Duncan Streets in 1880. Perhaps these gentlemen, and the dog, are enjoying a cigar break in the sun.

W. A. Rogers (left) and Johnnie Walker are lounging about, possibly outside the Rogers Hotel. Whether they were discussing Rogers's lodging business or Walker's cattle business we will never know for certain. One thing is for certain: these two men do look like the pioneers they were.

Tom Owens was the Rogers Hotel handyman. Here he is with his two coyote cubs. In addition to this handyman, the hotel had a bouncer, which proprietor William Rogers felt was necessary so female patrons of the hotel would not be annoyed by the male patrons' loud and uncouth language.

Two members of the Walnut Creek Forum are pictured here on December 28, 1899. The men are Robert and Charles Shuey, part of the early Shuey pioneer family. Homer Stow Shuey arrived in 1869 and purchased 57 acres near the junction of North Main Street and Mount Diablo Boulevard. He was the first to file a subdivision map in 1871 and began selling off lots.

The Shuey family was a prominent, civic-minded pioneer family in Walnut Creek. Shuey established himself in town around 1868 and later married his wife, Alice; had children; and settled down for their productive life in the hamlet. The old Shuey home was located on a hill between Bonanza Street and Mount Diablo Boulevard, just west of California Boulevard. Photographed here is the newer version of the Shuey home. (Photograph by Catherine Accardi.)

This is an image of several jury members for the Silk Works murder trial in August 1925. On the far right is Harry Spencer. Charles Henry Schwartz, Ph.D., was tried and convicted of the murder of one Gilbert Barber in a building then known as the Glove Factory. This building was located on Davis Street (now called Ygnacio) near the Sacramento Northern Railroad tracks (now North California Boulevard). This murder and subsequent trial was quite an event in those days.

106

In 1911, Harry Spencer is pictured here sitting in his lumber company office near the Southern Pacific Station. Harry Spencer was elected first president (mayor) of the board of trustees on October 22, 1914. At that time, the population of Walnut Creek was 500. On October 16, 1914, Walnut Creek was incorporated by voters, and the village became Contra Costa County's eighth city on October 21, 1914.

The Ayer and Spencer team of horses are in this 1911 photograph in the Spencer Lumber yard. Warren Nelson is the driver. In 1925, the Spencer Lumber Company drilled for water on the northeast corner of their property. This water supply was large and was rated so pure by the state water inspector that the City of Walnut Creek contracted with the company for 20,000 gallons a day to be pumped into city tanks. The cost was 3¢ a gallon.

Delbert McCombs is sitting in the driver's seat of this fire truck in front of the Ala Costa Inn on Main Street near Duncan Street around 1925. Walnut Creek's fire department has been well respected since the early days when Guy Spencer was the volunteer fire chief, later appointed the first official fire chief of the Central Fire District. He served until his retirement in 1954.

This is a photograph of the Walnut Creek Fire Department on October 15, 1938. They are standing in front of their modern fire truck. Second from the left on the truck is Joe Parkel. Standing sixth from the left is Guy Spencer, and seventh from the left is Ted Schroder. By 1954, the city had three fire stations and a fourth under construction.

This 1932 photograph is a view of the half-mile horse training track at Heather Farm. In 1874, it was the site of the Sulphur Springs Ranch, a popular health spa of the day. In 1920, John Marchbanks bought the 255-acre property to breed and train horses. Marchbanks named the facility after his stallion, Prince Heather. Heather Farm was the filming location of MGM's movie *Sporting Blood* in 1931.

This is the Heather Farm Mansion on Marchbanks Drive and Ygnacio Valley Road. Nearby property owner Philip Bancroft Jr. donated seven acres of his property east of North San Carlos Drive to the city for a park. The Walnut Festival Association contributed $105,000 to buy 13 acres for playing fields. The City of Walnut Creek bought the remaining acreage from the widow of John Marchbanks, who died in 1947.

Shown here is the Camellia Show Committee of the Mount Diablo Men's Garden Club with a beautiful camellia flower arrangement. The Garden Center at Heather Farm hosts flower shows, club meetings, and many interesting events for the city of Walnut Creek.

Pictured here is the entrance to the Ruth Bancroft Garden. The Ruth Bancroft Garden occupies land that was once part of a 400-acre fruit farm that produced walnuts and Bartlett pears in the Ygnacio Valley. The farm was started in the 1880s by Hubert Howe Bancroft, a famous historian and publisher. Philip Bancroft Jr. gave this land to his wife, Ruth, to plant a new garden using succulents from her large collection. In the early 1970s, Philip built Ruth's Folly, the wooden structure that marks the traditional entrance to the garden. (Photograph by Catherine Accardi.)

In April 1942, this Lions Club group met for the War Bond Drive in the courtyard of the Colonial Inn on Main Street. The Colonial Inn was formerly the Rogers Hotel, located in the original Rogers Hotel building, and owned by Mr. and Mrs. Dean at that time.

These are Buena Vista School children on a tractor on October 9, 1959. This photograph was used as publicity for the Buena Vista PTA Carnival.

Early doctors traveled through the area on horseback to make their calls. Young Dr. Leech arrived in Walnut Creek with his wife in 1897 from a Pennsylvania medical school to take up the practice of Dr. Joseph Breneman. Breneman was one of the first doctors to serve the village. Dr. Claude and Eva Leech were prominent Walnut Creek citizens from their arrival in 1897 until Claude's passing in 1934. He was a well-respected town doctor, and she was the first woman on the city council during the years 1931 to 1934. Their house above was at 1533 Main Street but was relocated a few feet in 1993 and converted into a restaurant.

This shows the John Muir Memorial Hospital under construction on Ygnacio Valley Road in 1964. It was named after the popular naturalist. A group of physicians began planning the hospital in October 1958 and purchased 10 acres for $31,675. After three years of construction, the $4.5-million, 100,000-square-foot facility opened on June 16, 1965, with 150 beds, 207 physicians, and 152 employees. In 1987, the name of the facility was changed to the John Muir Medical Center.

This 1947 photograph is of the Kitty Milk Bar at Locust and Bonanza Streets. It was located near the Clothes Horse, Jory's Flowers, Marshall Steel Cleaners, an optometrist, and the fire station. The Milk Bar was a busy place where children, and adults, could enjoy refreshing and tasty food during Walnut Creek's long hot summers.

Around 1947, the Nut Bowl Fountain at Main Street and Lincoln Avenue was another popular family hangout during those long hot summers. The Fountain was famous far and wide for delicious ice cream treats in a quaint building.

The Broadway Shopping Center is shown here in 1956. This shopping center was constructed at a cost of $1 million by San Francisco developer Graeme MacDonald and was the first retail center of its kind east of the Oakland hills. The Broadway Shopping Center opened on October 11, 1951, and quickly became the hub for shopping all over Contra Costa County and beyond. The original stores were Lucky, Sears, and J. C. Penney. Capwell's-Emporium was added in 1954. The name was changed to Broadway Plaza in 1985. In 1951, the center had 38 stores and shops, and by September 1994, it had grown to over 90 businesses.

This rendering is of the J. Larkey residence in 1879, located near North Main Street and Second Avenue. Larkey Park is now at this location. Larkey Park offers a restful oasis of lovely green lawns and trees, with two children's playgrounds, a swimming pool, and picnic area surrounded by gentle walking paths.

Mrs. Monroe Smith, president of the Diablo Junior Museum Alliance, is presenting a $1,700 check to Alexander Lindsay, president of the Diablo Junior Museum, on February 16, 1961. The Diablo Junior Museum was first established in 1955 at the Walnut Creek Grammar School. The museum was later renamed for the late Alexander Lindsay, a Walnut Creek school trustee.

Pres. Gerald Ford visited Walnut Creek on May 25, 1976. He came to Walnut Creek to dedicate a replica of the Liberty Bell donated by Soroptimist International of Walnut Creek to commemorate the U.S. bicentennial. That bell is now on display in Liberty Bell Plaza at Broadway and Mount Diablo Boulevard.

The Lesher Regional Center for the Performing Arts opened on October 4, 1990, with a gala fund-raiser starring Joel Grey, Vic Damone, Bob Hope, and Diahann Carroll. The performing arts center was named after a prominent area resident, Dean Lesher. Lesher purchased the *Contra Costa Courier-Journal* in July 1947. He later changed the name of this publication to the *Contra Costa Times*. Lesher was a Harvard Law School graduate who came west in 1941. (Photograph by Catherine Accardi.)

This is a rendering of the Capt. Orris Fales residence with a front and rear view in 1879. The location was near the corner of Near Court and Creekside Drive. Capt. Orris Fales purchased one acre of land in 1880 for 25¢. Fales's land bordered on that of Capt. Frank Webb and extended over what is now known as Olympic Boulevard. Fales married Webb's sister Ester and built a house near Creekside. It was standing until 1971, when it was removed to make room for apartment houses. It was back in September 1860 when the hamlet created a new school district. The school marshal was Captain Fales, whose duties were to take a census of the district to learn if a school building should be built and the number of pupils of school age. A school was finally opened in February 1861 with an attendance of 14 pupils.

This delightful bridge over Walnut Creek is adjacent to Civic Park. The bridge is in a very pleasant setting overlooking tree-lined creek banks and ducks. Note the creek walk sign on the right displaying the image of a bird. Birds, butterflies, and ducks, along with many other displays of nature at its best, can be found on this creek walk. (Photograph by Catherine Accardi.)

This is a photograph of the Antonio Silva de Botelho residence around 1883. In 1882, Botelho purchased the Walnut Creek and Mount Diablo Central Hotel, which he then used as his residence. He bought the rundown hotel on a one-acre site, and this purchase lent the Botelho name to a portion of downtown Walnut Creek. The hotel was originally built as a hostelry after the Walnut Creek House burned down in 1867.

Above is a rendering of the James Toomey Walker residence as it appeared in 1879. It was located on North Gate Road, where he owned a stock ranch. Walker and his family were early settlers in the Walnut Creek area. In 1868, Walker built this home on his 1,400-acre ranch, purchased in 1851. James's uncle, Joseph Walker, was a trapper, trailblazer, guide, and stock buyer of the 1830s and 1840s. Walker Pass in the Sierra Nevada is named for him. James's son, John "Johnnie" Walker, was born here, remained on the ranch after his father's death, and continued their cattle business for decades. They owned over 1,500 cattle. Johnnie was an equestrian who led the first Walnut Festival on October 2, 1936, atop his famous palomino.

In this 1947 photograph is Supervisor Ray Taylor, on the right, discussing supervisory matters at Geary and North Main Streets. Discussions to rezone Highway 21 were ongoing around this time. In those days, Highway 21 traveled through Walnut Creek and was one of the main roadways between Martinez and Walnut Creek.

This April 15, 1959, photograph is of, from left to right, Officer Jack Francis holding a puppet; Sheldon Rankin, Walnut Creek superintendent of schools; Mayor Farry Granzotto; and student Ricky Lowe. They are representing the Safety Town Program for schoolchildren. Farry Granzotto was mayor of Walnut Creek from April 8, 1959, to April 19, 1960.

These children are dressed up as crayons for an appearance in the Walnut Parade in 1950. Note each child's costume has the name of the crayon color on it. The festival provided a wide assortment of activities for children, including participating in the annual parade.

This image is looking at the entrance to the Art and Garden Center in 1947. Note the lovely statue and charming orchards all around. The Art and Garden Center became the area's cultural center during the 1940s. Several organizations met there regularly.

This is the Walnut Creek Women's Club meeting hall in September 9, 1937. For many years, members of the club devoted many hours and days to the civic betterment of the Walnut Creek community. Members raised money to pay off the debt on the town hall, opened the first community library for Walnut Creek in 1912, called for a village clean-up day, organized musicals at the town hall, and held a popular annual flower show.

Here are prize-winning cows preparing to participate in the Grape Festival Parade. The variety of entries was, and still is, amazing, as are these healthy-looking cows. The day of the parade was the time to show off fancy automobiles and floats. Grapevines hung from porches, eves, and storefronts. There were 500 people living in Walnut Creek at that time. The new event brought Walnut Creek to the attention of hundreds more.

King Walnut is in his costume on the right. For many years, King Walnut has been the mascot for the Walnut Festival Parade and the Walnut Festival Association. The first Walnut Festival was on October 2, 1936. Throughout the evening, the Mount Diablo Band played the American Legion's compound, "Days of '49." Mayor E. B. (Ed) Bradley crowned the queen for this first festival in what newspapers of the day described as the huge exhibition tent, where dancing went on until midnight. In later years, the festival was held in the city park. In future years, the Walnut Association became a successful fund-raising organization. Income from the private, nonprofit association built the art class building, provided seats for the Civic Arts Theater, funded the Alexander Lindsay Jr. Museum, furnished playground equipment at Civic Park, and funded a swimming pool at a local high school. Clearly King Walnut takes his job very seriously and he is quite successful.

Mary Ridgeway (back seat, center) was the Grape Carnival and Festival Queen in this 1911 photograph. Seated with her are Princesses Sybil Brown (back seat, left) and Grace Gertrude Walker. Gertrude was a clerk for the board of trustees. The driver is assistant district attorney Alfred S. Ornsby.

Pictured here is the Walnut Creek Lions parade float in the annual Walnut Festival Parade down Main Street. The parade is organized by various community groups and by the Walnut Festival Association. In the 1900s, the association donated $105,000 to purchase a 9-acre baseball field adjacent to Heather Farm Park and bought bleachers for Civic Park and the Clarke Pool.

Originally the Masonic Lodge met in Alamo, later in Danville, and then in Walnut Creek on January 4, 1878. The first meeting of the Masonic Lodge in Walnut Creek was in the upstairs of a two-story building owned by the lodge and James M. Stow. That building was removed and the Cameron Building constructed in its place. The second Masonic Lodge building was erected on Locust Street and Mount Diablo Boulevard in 1916. It too is now history.

This is the residence of Erasmus Ford at the south end of School Street (now Locust Street), as it looked on November 1, 1956. Ford arrived in the Walnut Creek area in 1852. He built this home for his wife, Ellen Ford, and their family around 1870. Ellen was appointed Walnut Creek postmaster on September 6, 1900.

The Baker family occupied this ranch residence from 1853 to 1913. In front, from left to right, are John and Martha Baker, Calvin Baker, Mary Baker, George and Ralph Raven, and a dog.

Theodore "Ted" Wiget is shown here in his drugstore in 1926. Ted opened his store in the 1300 block of North Main Street in 1913. He carried a wide variety of merchandise besides medications. Although there were several pharmacies in Walnut Creek by the 1920s, the first drugstore, then called a dispensary, was opened in 1878 by Dr. Joseph Pearson and his wife, Sara Pearson. After Pearson's passing, his widow continued to operate the store until 1938.

This c. 1951 photograph shows Mount Diablo with snow and Walnut Creek at its base. In 2008, U.S. News and World Report magazine voted Walnut Creek one of the "Best Places to Retire." A September 19, 2008, article in the Contra Costa Times read: "A moderate climate combined with roughly 2,700 acres of open space and other attributes landed Walnut Creek a spot on the national magazine's list of cities that offer ample opportunities for active retirees to focus on their physical and mental health. More than a suburb of San Francisco, Walnut Creek has a character of its own." U.S. News and World Report said an abundance of recreational activities, 22 public parks, the very popular Lesher Center for the Performing Arts, Diablo Valley Lines Model Railroad, and about 75 restaurants were just a few of the reasons Walnut Creek, the city in the valley, is a great place to live. Walnut Creek is the perfect image of America.

www.arcadiapublishing.com

Discover books about the town where you grew up, the cities where your friends and families live, the town where your parents met, or even that retirement spot you've been dreaming about. Our Web site provides history lovers with exclusive deals, advanced notification about new titles, e-mail alerts of author events, and much more.

MADE IN THE USA

Arcadia Publishing, the leading local history publisher in the United States, is committed to making history accessible and meaningful through publishing books that celebrate and preserve the heritage of America's people and places. Consistent with our mission to preserve history on a local level, this book was printed in South Carolina on American-made paper and manufactured entirely in the United States.

This book carries the accredited Forest Stewardship Council (FSC) label and is printed on 100 percent FSC-certified paper. Products carrying the FSC label are independently certified to assure consumers that they come from forests that are managed to meet the social, economic, and ecological needs of present and future generations.

FSC
Mixed Sources
Product group from well-managed forests and other controlled sources
Cert no. SW-COC-001530
www.fsc.org
© 1996 Forest Stewardship Council

Find Your Place in History.